Pidgin as Curatorial Method:

Messing with Languages and Praxes of Curating

Pidginization as Curatorial Method

Messing with Languages and Praxes of Curating

Bonaventure Soh Bejeng Ndikung

Pidginization as Curatorial Method:

Messing with Languages and Praxes of Curating

Thoughts on Curating, volume 3
Edited by Steven Henry Madoff

Introduction

Over the past twenty years, I have tried to theorize and practice what one might call "curating tangentially." By that I mean a praxis of curating that is anecdotal rather than direct, linear, or elaborative. A praxis of curating that sits comfortably in that space of *chercher midi à quatorze heures*, which literally translates as "searching for noon at 2:00 p.m.," but actually implies beating around the bush. A praxis of curating that aims at stretching what I had previously understood to be curating—although the bar was already set very high if one thinks of how I came to curating... or, better said, how curating came to me.

It was 1998, and I had left Bamenda and Yaoundé for Berlin, where I had been based for almost a year. In my twenty years of living in Cameroon, I had never come across the word "curator," let alone heard of the possibility of studying a discipline of the sort. It was the announcement of Okwui Enwezor as artistic director of documenta 11 that brought this discipline to my attention. Prior to that announcement, I had never seen an African, a Black African, on prime-time TV in Germany, especially a nonpolitician, a nonsportsperson, a nonentertainer, and an intellectual, for that matter. This announcement left such a deep impression on me that the discipline of curating became engraved in my mind. But being a twenty-one-year-old migrant who had to fend for himself to pay school fees, earn a living, and support family back in Cameroon,

it seemed rather unlikely that studying anything other than engineering or something in the medical field was an option. And that is how, in my twenties, curating became secondary and the natural sciences and engineering primary, only to be radically reversed in my thirties.

Maybe it was because the curators I observed and tried to learn from (though from afar), like Simon Njami, Olu Oguibe, and Enwezor, were all invested in one form or another of poetry and curating soon became to me a very close sibling of poetry. If it weren't for the magnanimous respect and *Ehrfurcht*, or awe, for poetry and the practice of poets, I would claim that this curatorial practice I have tried to establish over the past two decades *is* poetry. But what is certain is that it's within the realms of the poetic and of poesis. What is also certain is that the curatorial practice I learned by proxy and developed over the course of time is a form of both collage and bricolage. A space in which distances between disciplines collapse, in which forms collide and learn to flow into and through each other. A space in which sociopolitical, economic, ethical, and spiritual concepts and questions are negotiated. A territory in which hierarchies are put to the test, challenged, and conviviality and hospitality are offered as methods. A curatorial practice that is tasked with the propositioning and positioning of multiple epistemologies. But ultimately, the curatorial practice I have tried to work with and work through is a practice of *pidginization*.

In this essay, I will try to unpack this practice of pidginization as it relates to curating, language, and culture at large. It is at its core anecdotal. For it is a curatorial practice based on storytelling. It is idiomatic, as it is a curatorial practice colored by and framed within cultures in which the art of packing and unpacking riddles is fundamental. How can we imagine, conceptualize a curatorial practice based on the craft of proverbs, on the proverbial, on proverbing as a practice of implementing, of employing art as a possibility of expressing deeper truths founded on our common and multiple experiences, senses, ontologies, and epistemologies? But how can we also conceptualize a curatorial practice based on proverbing as a practice of thinking and acting critically avant la lettre? A practice that precedes the word and a practice that informs and is informed by the subtleties and complexities of language(s).

What follows is an anecdotal rumination on my storytelling practice of curating that employs pidginization (a term I will elaborate on below) as its raison d'être and has pidginization as its crux. It is an effort to understand the exhibition space as a proverbial fireside where stories are told through art in context—employing the tools of anecdotes, proverbs, idioms, metaphors—and in which various worlds are invoked and others revoked.

We way we nova get ntong fo go sucool fo sy fo Ngwayikele, na fo sauvetage we di find we own garri. Fo dis heure fo austerité so, aman fo dis heure weh cinq no musi change position, yes austerité dat be say dollar no musi change foot. Wusai we own espoir dey noh?

—Lapiro de Mbanga, "Mimba We"

She was acting too damn *haolefied*. Whenever anybody spoke goody-good English outside of school, we razzed them, "You think you *haole*, eh?" "Maybe you think you shit ice cream, eh?" "How come you talk through your nose all the time?" Lots of them talked nasally to hide the pidgin accent. At the same time the radio and *haole* newspapers were saying over and over, "Be American. Speak English." Pidgin was foreign.

—Milton Murayama, *All I Asking for Is My Body*

On the other hand, she often finds herself at odds with language, which partakes in the white-male-is-norm ideology and is used predominantly as a vehicle to circulate established power relations. This is further intensified by her finding herself also at odds with her relation to writing, which when carried out uncritically often proves to be one of domination: as holder of speech, she usually writes from a position of power, creating as an "author," situating herself above her work and existing before it, rarely simultaneously with it.
—Trinh T. Minh-ha, *Woman, Native, Other*

From the principle of adaptation came the cultural process known as creolization. From the principle of resistance comes the separation principle which I label maroonage. From the contradictory adaptation/resistance process comes the concept of indigenization. These three processes lead to three well defined philosophies of action on the part of blacks in the New World. Creolization leads to the philosophy of integration. Maroonage leads to the principle of separation. Indigenization must lead to the principle of liberation. What we are witnessing today all over the world is the eruption of the natives of the world from their marginal reservations into the mainstream of the supernatural systems.
—Sylvia Wynter, "Black Metamorphosis: New Natives in a New World"

Anecdote I:
My Heart Di Cut

Tita was what one could call, without much doubt, a fine student. He excelled especially in science subjects like biology and physics, and at any given time, Tita could multiply or divide to solve the most complex mathematics problems posed. Indeed, he was an ace in algebra and other subjects, which convinced his teachers to think he, though still in form three of secondary school, was predestined to become an engineer. Despite these accolades, Tita had become a kind of unintentional comedian on the school campus, as whenever he was tasked to make a statement longer than six words, his fellow students would burst into laughter. Tita was the first in his family to attain secondary school education, and at home his family communicated in his mother tongue, Nguemba, or the more widely spoken language, Pidgin. Tita wasn't just fluent in both languages, but mastered their idioms, proverbs, and other ins and outs, especially in Pidgin. He was an acrobat of Pidgin, and besides colloquial Pidgin, he also mastered the more advanced version, spoken by the truck pushers, market men and women, and *sauveteurs* of Nkwen and Ntarinkon parks, popularly known as "Mboko Tok." Though a brilliant student, English classes were always a nightmare for Tita. Well, being in school in general had slowly become a nightmare, as the Marist Brothers in charge of his Catholic secondary school had prohibited the

speaking of any languages in school other than the "Queen's language," English; French, too, was tolerated. But if you were caught speaking Pidgin or some other language deemed "primitive" by the minds of those rotting in the deep decayed soup of coloniality, you were given a few lashes with a whip or, if you were lucky, a punishment of cutting grass with a blunt machete awaited you.

Tita, an otherwise judicious student, despite investing his best in speaking the "Queen's language," was—more in a creeping, possessing way, like an addiction you can't let go—often suddenly gripped by the tentacles of the omnipresent Pidgin in his life. Too often in the middle of a sentence, he would say, "sef," "nobiso," "ateyu," "mimba," or some other expression to punctuate what he was saying and spice up his language. But it brought roaring and humiliating laughter from the ruthless teenagers around him at school. It is for this reason they christened him "Shalemagne"—a not-so-appealing compliment, as the root word "shale" means to blunder, to be faulty, to make mistakes and be clumsy, braided with the name of Charles the Great, Charlemagne, King of the Franks and Lombards, and Emperor of the Romans. In short, Tita was taunted as the emperor of destruction of the "Queen's language."

Yet it was Tita's composition for an English class that gained him lasting fame and immortalized his presence at the school. He was an eloquent narrator, and when he spoke or wrote, he could conjure such vivid, such articulate imagery. So it

was with a composition in which he described a frightening situation he found himself caught up in. And that is how, in the middle of this composition, he exclaimed: "My heart over cut, but I tied my heart!" One could consider this magnificent bit of Pidgin imagery translated into English an unintentional massacring of language, as Tita's English teacher and most others present to hear it chose to think, causing Tita the greatest chagrin. But soon enough there was a general consensus that he couldn't have done otherwise, as the English language, like many other colonial languages, just wasn't enough—in terms of depth and breadth, sophistication and nuance—to carry its speaker's fears, pains, joys, or other concerns. It was the limit of the language that had prompted him to stretch it, to make it more elastic, more porous, more accom-modating. And essentially, that is what Pidgin is or strives to do in communication.

What Pidgin does, with its endless agency, is subvert colonial languages and other languages from which it is constituted. Pidgin is always more than the sum of its parts, much faster in its devel-opment than the languages from which it feeds, and always much richer and more pliant. Fundamentally, Pidgin is not a language, but a way of being in the world that, for nomenclature's sake, can be called pidginization. As a way of being in the world, pidginization presents a philosophy, a practice that constantly engages with and provokes the prefix "sub-" and has no complex about feeling comfortable in that subterranean, subcultural, and ultimately

15

subversive space. "Sub-" not as in being underneath anything, being inferior, but rather as an undermining of power structures, of language hegemonies, of authoritative systems, of institutional hierarchies, of patriarchal heteronormative structures—all of which come from or are spiced with what the sociologist Aníbal Quijano calls "the coloniality of power."

In Bernard Caron and Francis Egbokhare's 2018 presentation at the Institut Français du Nigéria, "From Stigma to Coolness: The Emergence of Naija (Nigerian Pidgin) as a 100 Million Speaker African Language," they elaborate on how a hitherto disdained language, Nigerian Pidgin English (NPE)—so often used under the duress of physical and mental abuse in schools and other structures of power, as was Tita's case—has become ubiquitous in public spheres in Nigeria, spreading its multiple tentacles into radio and TV, into films and music, into advertising. As well, it has become an all-pervasive presence in private spaces, a lingua franca for millions of people who share hundreds of other languages. After pointing out how Pidgin has placed its roots deep in culture, business, politics, and beyond, Caron and Egbokhare ask why Pidgin is still generally ignored, why it still suffers from so many misunderstandings and stereotypes? The obvious answers range across stereotypes broadcast by the media regarding Pidgin as a broken language fit just for kids, illiterates, the mentally deficient; Pidgin as a language of the primitive, lazy, and corrupt.

One thing all these insults share is that they come from the playbook of the colonial enterprise

that sees the cultures and knowledges of Indigenous people as rudimentary and primitive, while those of the colonizer are seen as superior and more developed. It is these falsities that have been told and retold for more than one thousand years that pidginization seeks not only to subvert but also to lay bare, to expose and call out. Which is to say, pidginization per se is not limited to the vast range of Pidgins, but is a process of counternormativity that proposes indigenized, syncretic ways of going forward that go beyond just the Creole. And it is for this reason (i.e., because of pidginization's incendiary potential, its ability to dismantle) that structures seeking to maintain colonial supremacy must do everything to stand in pidginization's way. But being amebic, as malleable as it gets, pidginization has learned to lurk in the shadows and crouch under the weight of coloniality, waiting for its time to "jerrup" and slip through the cracks and crevices of power.

Anecdote II:
He be so them dey do,
them dey overdo / Colo-mentality

It might be important to mention that Tita didn't go to school in the heart of the colonial era. Those who chastised him most—with both physical and psychical thrashings—were his own. Postcolonial subjects who desperately needed to be holier than the pope. Those who wanted to speak using their noses instead of their mouths to sound as white as possible, as Milton Murayama aptly points out in *All I Asking for Is My Body*. Those who had internalized the demeaning, denigrating, dispiriting, derogatory claims placed on them by the colonialists. But it is the great musician and activist Fela Kuti who most justly describes them—no, sorry, makes an anthem for them—with his 1977 renegade song "Colonial Mentality" on his album *Sorrow, Tears, and Blood*. This funky, groovy, rhythmic piece, whose first seven-and-a-half minutes is an instrumental ushering in a grandstand of sonic genius and political discourse, invited listeners to the dance floor not only to shake their bodies but also to shake off that overbearing weight of coloniality.

 1977 was a year that called for a radical political reckoning for African nations almost two decades after independence. But the situation wasn't looking rosy. Nigeria had just come out of a coup the year before that led to the assassination of its president, General Murtala Muhammed,

by Lieutenant Colonel Buka Suka Dimka, among others. In the chaos, the military triumvirate of Generals Olusegun Obasanjo, Shehu Yar'Adua, and Theophilus Danjuma swept to power. While Nigeria wasn't proving capable of assuming an independence worth its name, South Africa's apartheid system had already attained a peak of power the year before, during the 1976 Soweto uprising that was led by Black school children protesting the introduction of Afrikaans as the main means of instruction in local schools (just as English was imposed in Tita's school and many others). The mainly peaceful protests by twenty thousand students were met with excessive and entirely inappropriate violence by the white police establishment, opening fire and killing hundreds of people, including the cold-blooded shooting of fifteen-year-old Hastings Ndlovu and twelve-year-old Hector Pieterson at Orlando West High School. Just a few months later in Nigeria on February 18, 1977, over one thousand armed forces stormed Fela's communal home, the Kalakuta Republic, a sprawling compound in the suburbs of Lagos that he created and shared with family and many others. The soldiers threw his mother from a window—she later died from the injuries sustained from this barbarous act—and the compound was burned to ashes.

All of these occurrences must have instigated, fueled, and catalyzed Fela's reflections on the deep, deep damage to Africans brought on by the colonialist mentality. Be it language, culture, politics, economy, governance, it seemed minds had been

corrupted by this mentality that stops a child from speaking their own mother tongue or pushes parents to give their children European names—a crisis in identity reflected in the fight against pidginization and that Fela, in Pidgin, duly sings:

> If you say you be colonial man / You don be slave man before / Them don release you now / But you never release yourself / I say you fit never release yourself / Colo-mentality / E be say you be colonial man / You don be slave man before / Them don release you now / But you never release yourself / E be so / He be so them dey do, them dey overdo / All the things them dey do (He be so!) / E be so them dey do, them think dey say / Dem better pass them brothers / No be so? (He be so!) / De ting wey black no good / Na foreign things them dey like / No be so? (He be so!) / Dem go turn air condition / And close Dem country away / No be so? (He be so!) / Them Judge him go kack wig / And jail him brothers away / No be so? (He be so!) / Dem go proud of dem name / And put dem slave name for head / No be so? (He be so!) / Colo-mentality now make you hear me now / Colo-mentality! / Mr. Ransome you make you hear / Mr. Williams you make you hear / Mr. Allia you make you hear / Mr. Mohammed you make you hear / Mr. Anglican you make you hear / Mr. Bishop you make you hear / Mr. Catholic you make you hear / Mr. Muslim you make you hear /

Na Africa we dey o make you hear / Na Africa
we dey o make you hear / Colo-mentality
hear / Colo-mentality hear / Mr. Ransome
you make you hear / Mr. Ransome you make
you hear / Na Africa we dey o make you hear
/ Na Africa we dey o make you hear / Colo-
mentality hear / Colo-mentality hear.[1]

The postcolonial predicament is to be steeped
knee-deep, waist-deep in the filth of colo-mentality.
In some circles, Fela wasn't listened to—not because
his criticism of the conditions of his people, of the
government, and the complacency of his cotravelers
wasn't razor sharp, but because he sang in Pidgin
and practiced pidginization as a *mode de vivre*.

Almost ten years after Fela composed
"Colonial Mentality," the Kenyan novelist and
scholar Ngũgĩ wa Thiong'o published his seminal text
"Decolonising the Mind: The Politics of Language
in African Literature," in the early pages of which
he wrote a statement about how in 1977, the year of
"Colonial Mentality," he said farewell to the English
language as a vehicle for the writing of his plays,
novels, and short stories, and switched to Gĩkũyũ
and Kiswahili. The text is a fierce reckoning with the
politics of language, and language as a key element in
any decolonizing effort, as

1 "Colonial Mentality," track 2 on Fela Kuti, *Sorrow Tears and
 Blood*, Kalakuta, 1977.

the choice of language and the use to which language is put is central to a people's definition of themselves in relation to their natural and social environment, indeed in relation to the entire universe. Hence language has always been at the heart of the two contending social forces in the Africa of the twentieth century. The contention started a hundred years ago when, in 1884, the capitalist powers of Europe sat in Berlin and carved up an entire continent, with its multiplicity of peoples, cultures, and languages, into different colonies.[2]

For Ngũgĩ, if these languages that are generative of cultures and philosophies were at the root of colonial violations, then one must question their appropriateness as vehicles of African (or formerly colonized) thoughts, stories, cosmogonies, ethics, politics, and being. Ngũgĩ writes, too, of the historic meeting in 1962 of African writers at Makerere University in Kampala, Uganda, which he attended. The question of language seemed to have been the elephant in that room filled with the most prominent African writers at the time. And from that context, Ngũgĩ asks some very pertinent questions:

> How did we arrive at this acceptance of "the fatalistic logic of the unassailable position of English in our literature," in our culture and

2 Ngũgĩ wa Thiong'o, *Decolonising the Mind: The Politics of Language in African Literature* (London: James Currey, 1986), 9.

in our politics? What was the route from the Berlin of 1884 via the Makerere of 1962 to what is still the prevailing and dominant logic a hundred years later? How did we, as African writers, come to be so feeble towards the claims of our languages on us and so aggressive in our claims on other languages, particularly the languages of our colonization?[3]

Ngũgĩ speaks to the importance of language in storytelling in his childhood when he writes:

We therefore learnt to value words for their meaning and nuances. Language was not a mere string of words. It had a suggestive power well beyond the immediate and lexical meaning. Our appreciation of the suggestive magical power of language was reinforced by the games we played with words through riddles, proverbs, transpositions of syllables, or through nonsensical but musically arranged words. So we learnt the music of our language on top of the content. The language, through images and symbols, gave us a view of the world, but it had a beauty of its own. The home and the field were then our pre-primary school, but what is important, for this discussion, is that the language of our evening teach-ins, and the language of our immediate and wider community, and the language of our

3 Ngũgĩ, 11.

work in the fields were one. And then I went to school, a colonial school, and this harmony was broken. The language of my education was no longer the language of my culture.[4]

Then he goes on to write that

it was after the declaration of a state of emergency over Kenya in 1952 that all the schools run by patriotic nationalists were taken over by the colonial regime and were placed under District Education Boards chaired by Englishmen. English became the language of my formal education. In Kenya, English became more than a language: it was *the* language, and all the others had to bow before it in deference.

Thus, one of the most humiliating experiences was to be caught speaking Gĩkũyũ in the vicinity of the school. The culprit was given corporal punishment—three to five strokes of the cane on bare buttocks—or was made to carry a metal plate around the neck with inscriptions such as I AM STUPID or I AM A DONKEY. Sometimes the culprits were fined money they could hardly afford.[5]

4 Ngũgĩ, 11.
5 Ngũgĩ, 11.

Ngũgĩ wa Thiong'o's story is Tita's story; it is the story of many Africans, Asians, Abya Yala people, and many Indigenous and colonized peoples around the world. In drifting away from, refusing, revolting against those languages, cultures, and technologies of supremacy, Ngũgĩ and Fela Kuti establish another way through pidginization.

Anecdote III:
The Eruption of the Natives of the World: Creolization, Maroonage, Indigenization

Sylvia Wynter's "Black Metamorphosis: New Natives in a New World" is one of the most important, though unpublished, deliberations on Blackness and Black thought. In it, she offers a triangle of concepts that have been fundamental in Black struggles across time and geographies: *creolization*, *maroonage*, and *indigenization*. According to Wynter, creolization is a process of adaptation and essentially an integrationist and assimilationist project, about which she gets granular in writing about Jonkonnu, the Caribbean Christmas celebration that blends African and English traditions of mumming and masquerade. She states, "The cultural concept of creolization therefore meant a self-conscious attempt to be culturally half-castes and to deny the cultural dynamic of their being."[6] In her reflections on maroonage, Wynter points out that at its core it is the principle of resistance to attain the goal of separation and autonomy. Wynter's understanding of maroonage exists in a wide spectrum that stretches from the escape of plantation slaves to Marcus Garvey's Universal Negro Improvement Association. About the latter, she writes:

6 Sylvia Wynter, "Black Metamorphosis: New Natives in a New World" (unpublished manuscript, n.d.), 116.

Later, Garvey's international New World Movement, his Back to Africa campaign, was more far reaching in its scope. It translated the age old dream of return into modern terms: not the return of the dead but of the living to the homeland. But it too held elements of a maroonage, an escape into a "reservation." Africa was to be "reserved" for the black man wherever he came from. His life in the New World, and what he had built in it, was to be negated. These centuries of diaspora had been a mere nightmare to be ended and quickly forgotten.[7]

When it comes to indigenization, Wynter considers this concept a culmination of adaptation and resistance as well as a subversive act. In writing about Martin Luther King, she points out, "It was no accident that such a movement happened in the South. It is there that the process of 'indigenization,' a dialectical process of resistance and adaptation, had objectified itself in the black Churches. The oratory of Martin Luther King, a fusion of words and music, and rhetoric which sprang from spirituals, blues, the entire gamut of the African experience in the New World, came out of this process."[8] In her further reflections on indigenization, she elaborates:

7 Wynter, 183. Editor's note: Wynter refers to the "New World Movement," which is more commonly referred to as the "Garvey movement."
8 Wynter, 222.

In this overall context, the process that I have tried to define in this monograph as the cultural process of INDIGENIZATION takes on varied dimensions. In constituting an other self, an other collective identity whose coding and signification moved outside the framework of the dominant ideology, the slaves were involved in a long and sustained counter struggle. Slave revolts were the punctuations of this struggle, the violent strategies carrying on the struggle by other means. What I am arguing is that what Elkins, in his postscript essay, defines as the mechanism of rebellion, was to be found in this constitution of an alternative culture. The constitution of this culture has been all along a sustained act of cultural subversion, a subversion of the dominant system as axiomatic.[9]

It seems to me that Pidgin and pidginization—as language and cultural bearing—exist within the same realm, surf on the same waves, ride on the same wavelengths as Wynter's concept of indigenization. The proposition of pidginization here is not synonymous with creolization, which, though a very important concept, is caught up too often in the adaptation and integrationist project. It is this contradiction of adaptation and resistance, this endless striving for subversion, this maroonage tendency and functionality of Pidgin and pidginization that make it a more

9 Wynter, 410.

than important way of being in the world for us. How can we imagine and conceptualize pidginization as the constituting of an other self beyond that of the violent and violating narrative? How can we imagine and conceptualize pidginization as that cue to plant and let germinate collective identities whose codings and significations lie outside of dominant and dominating ideologies? As a language, Pidgin cannibalizes the language of the colonizer, churns it with varying languages of the colonized to spit out a transformative and transforming language and culture.

Anecdote IV:
Scatta-Balanz

In boarding school, "scatta-balanz" was the term used by the senior students to describe the kind of punishment they gave to younger students. Scatta-balanzing consisted of a slap on one side of the face as the action, and a counter-slap on the other side of the face as a reaction. A vile modern-day version of Luke 6:29: "And unto him that smiteth thee on the one cheek offer also the other." While colloquially we had adopted and reappropriated scatta-balanz to mean something that shakes and destabilizes you profoundly, etymologically it actually means to dismantle and remantle. This, too, seems to be what Pidgin and pidginization perform.

Linguist Kofi Yakpo points out peripherally, in his paper "Betwixt and Between: Causatives in the English-lexicon Creoles of West Africa and the Caribbean," that Nigerian and Ghanaian Pidgin, for example, "have been in direct, uninterrupted contact with English since their creation or implantation in West Africa and have thereby invariably been affected and shaped by English."[10] Yakpo proposes many very important scientific findings that have been fundamental in the development and understanding

10 Kofi Yakpo, "Betwixt and Between: Causatives in the
 English-lexicon Creoles of West Africa and the Caribbean," in
 Analytical Causatives: From 'Give' and 'Come' to 'Let' and 'Make,'
 ed. Jaakko Leino and Ruprecht von Waldenfels (Munich:
 Lincom Europa, 2012), 11.

of Pidgin languages, along with a few noncentral points that are nonetheless important for my reflections on pidginization. For example, because of this long and uninterrupted relation between Nigerian Pidgin and the English language, the former is understood as a broken version of the latter. This pejorative, derogatory, and racialized depiction of Pidgin as a defective version of English is interesting as a point of reference in thinking of scatta-balanz in Pidgin, and that Nigerian Pidgin, for example, can be understood as an other, as a remantling with its own integrity, its own beat, its own generative maroonage.

Another point of interest within this context is the question of fragmentation, which Yakpo discusses in terms of fragmented modal domains, but also in terms of history and geographical bearings, when he writes:

> In terms of speaker numbers and geographical distribution, the chain of often mutually intelligible AECs [Afro-Caribbean English-lexicon Creoles] must be counted as one of the largest lectal continua of the Western hemisphere. The AECs form a comparatively young family. They arose during the European slave trade from the sixteenth century onwards, crystallized as stable linguistic systems and native languages to the enslaved and free African-descended population of the colonial Caribbean, have since then differentiated along the political and geographical fragmentation of the territories they have been spoken in, and have

seen a massive expansion in speaker numbers, particularly in West Africa in the wake of nation-building in the post-independence period since the 1960s.[11]

Within this anecdote of scatta-balanz, it is important to appropriate these concepts of brokenness and fragmentations of varying kinds in the effort to understand and frame Pidgin and pidginization in terms of assemblage/reassemblage. To make this argument for them as assemblage, I want to borrow from a non-Pidgin scholar's work—Anna Lowenhaupt Tsing's *The Mushroom at the End of the World: On the Possibility of Life in Capitalist Ruins*, where she writes:

> Assemblages don't just gather lifeways; they make them. Thinking through assemblage urges us to ask: How do gatherings sometimes become "happenings," become, that is, greater than the sum of their parts? If history without progress is indeterminate and multidirectional, might assemblages show us its possibilities? [...] Other authors use "assemblage" with other meanings. The qualifier "polyphonic" may help explain my variant. Polyphony is music in which autonomous melodies intertwine.[12]

11 Yakpo, 2.
12 Anna Lowenhaupt Tsing, *The Mushroom at the End of the World: On the Possibility of Life in Capitalist Ruins* (Princeton, NJ: Princeton University Press, 2015), 23.

The argument is that instead of understanding Pidgin or pidginization as a broken version of any language or culture, they must be understood as a gathering of a plurality of languages, lifeways, cultures, philosophies, ways of existing in the world, whereby the gathering is always larger than the sum of its parts. Instead of understanding Pidgin or pidginization as a broken version of any language or culture, they must be understood within the realm of performativity, i.e., when these aforementioned gatherings become "happenings," always in action, in transformation, in processuality—doing and undoing themselves. Instead of understanding Pidgin or pidginization as a broken version of any language or culture, they must be understood from that vantage point of indeterminacy and multidirectionality wherein histories and geographies collide, whereby distances between cultures and social imaginations collapse. And ultimately, instead of understanding Pidgin or pidginization as a broken version of any language or culture, they must be understood as polyphony. The polyphony of the quotidian in the Pidgin spoken at home, in markets, in bars and restaurants, in the dormitories of schools that have prohibited the speaking thereof, but also the polyphony in the music made with and through Pidgin. Pidginization as a method of curating proposes a polyphonic and multidirectional practice of curating.

Anecdote V:
Stories of Encounters and Resistances

"Malum hab cuttee he head?" he said. "What for wanchee this piece boy? He blongi boat-bugger—no can learn ship-pijjin. Better he wailo chop-chop."

Zachary's voice hardened. "Serang Ali," he said sharply; "I don need no explateratin here: I'd like you to do this, please."

Serang Ali's eyes darted resentfully from Paulette to Jodu before he gave his reluctant assent. "Sabbi. Fixee alla propa."

pijjin/pidgin: "Numerous indeed are the speculations on the origins of this much-used expression, for people are loathe to accept that it is merely a way of pronouncing that commonest of English words: 'business.'" But such indeed is the case, which is why a novice or griffin is commonly spoken of as a learn- or larn-pijjin. I have recently been informed of another interesting compound, stool-pijjin, which is used, I believe, to describe the business of answering Nature's call.
—Amitav Ghosh, *Sea of Poppies*[13]

13 Amitav Gosh, *Sea of Poppies* (London: Picador, 2008), EPUB version, 152, 545.

There is a general consensus that Pidgin is a language of encounter, and that what led to most of these encounters that then birthed many Pidgin forms was what we call business or, better put, capitalist enterprise. For Indigenous people to communicate with their exploiters and with the others taken hostage, syncretic languages had to be created in situ. To buy and sell the exploited goods and humans, syncretic languages had to be created in situ. That is why on the ships, like in Amitav Ghosh's *Sea of Poppies*, Pidgin was the lingua franca. But it would be doing injustice to Pidgin to consider it just a language of capitalist enterprise, as its etymological roots suggest.

In those same spaces of capitalist encounters and exchange, especially considering the plenitude of hierarchies of cultures, classes, races, and geographies cultivated in such spaces, Pidgin very quickly became the medium through which resistances could be formulated. Audre Lorde famously said that we can't use the master's tools to dismantle the master's house. But if we were to complicate this statement a bit further, we would say that the so-called master never built a house in the first place. What he did was destroy existing houses that we so desperately need to rebuild at this point in time in world history. Pidgin is the collection of tools used to dismantle our houses, in addition to our own endemic tools. Pidginization is the act and culture of using these multiple tools to repair and rebuild. Pidginization is resistance.

After about eight minutes of serious, heavy sounds driven by drums, synths, keyboards, and various horn arrangements, Fela Kuti—who dropped his middle name, Ransome, in 1975, considering it a slave name, and replaced it with Anikulapo (which means "one who carries death in his pouch," that is, one who controls one's own life and death), in what might be called these days a decolonial gesture—finally gets to the crux of his seminal piece, "Mr. Grammarticalogylisatitionalism is the boss," from the 1976 album *Excuse O*. One could indeed argue that Fela's "Mr. Grammarticalogylisatitionalism is the boss" is one of the most, if not *the* most, astute critiques of language within the postcolonial condition. A condition that flags the violences and wounds of our colonial legacy every time we open our mouths. Towards the middle of that song, Fela Anikulapo Kuti calls on us, begs us, his brothers and sisters, to listen to him now:

> Wey talk oyinbo well well to rule our land o ... / Him talk oyinbo pass English man! / Him talk oyinbo pass America man (him talk oyinbo pass English man) / Him talk oyinbo pass French man (him talk oyinbo pass English man)/ Me I say him talk oyinbo pass Germany man (him talk oyinbo pass English man) / The better oyinbo you talk / The more bread you go get.

He goes on to sing of how the colonizer's language and the striving to become even more colonial

than the colonialist—which, as discussed, he calls in another song "colo-mentality"—has taken hold of us and translates to economic value, the way language affects the people who rule us, our academic structures, our daily news, our quotidian. Bogus languages that have filled the pages of newspapers, that express things that teachers, traders, laborers, and people of all walks of life won't understand. There is something very uncanny about what happens when a colonial language displaces the mother tongue of the colonized and the postcolonial being in that equation called communication. (Or, if language or communication were a chemical reaction, then colonial languages are the displacement agents that have uprooted the Indigenous languages of colonized and postcolonial peoples.) So, the work of artists like Fela Kuti, Lapiro de Mbanga, and FOKN Bois, among others, could be understood as the possibility of cultivating pidginization as that space of resistance against colo-mentality. Pidgin, as a business language, a language of exchange on many levels, could be the language used in the service of dismantling the capitalist enterprise or, at least, could be deployed to shake neoliberal capitalism's foundations.

In Lapiro de Mbanga's "Pas Argent," he sings about how he meets a young woman and declares his love to her: "Cheri coco, ma pomme de France, mon tresor, cherie de tout mes amours les plus distinguer. Je time, a tingue zam, je t'adore, a euh'hem." And she interrupts him, replying, "Silence me dit elle. Meu meu meu meu. On tas dit que je menge cheri coco

je t'aime?" The woman goes on to explain the dire economic situation of the world and then informs Lapiro that if he wants her, the only thing that counts is money. The story continues with Lapiro taking the train from Mbanga to Kumba, where he meets this beautiful woman, and the conversation goes like this:

> "Mamiii."
> "Papiiiii."
> Na ye weh ay say, "Mama ay don fo ya model baddddd. Ana Ay be Jonny just com. Na fo Mbanga ay comot. And ay see say today me na you fit sign contrat. How you see?"
> E say, "No problo."
> "D'accord callé fo ya."
> "Mami na yeti you di soul noh?"
> "Ehhh I de soulé na becks beer."
> "Alright... da deh I buy one. E blow e blow e blow e crep am."

Lapiro goes out to get suya for both of them: "Time weh ay put wan fo mop mama put two fo mop. Ay put wan fo mop, mama put fav fo mob." Then he goes to buy cigarettes and the same game happens: "Ay smok wan, mama smok three ..." Fast forward to the moment they get home, and Lapiro starts negotiating the next move for the evening, and our sister replies: "Ehhhh ... you know say tomorrow na Kumba market. And we get we njangi fo fes fo mami Maria weh we di call am say biabia bar. So e fine say you try shake ya skin gi me money."

Lapiro says, "Oh oh we weh ay like you plenty so?" And she interrupts, "Shut up ya dirty mout my frend. You hear say ay day chop like? Beg gi me money oooh. Money fo bag, back fo groun."

At the crescendo of this seminal piece, Lapiro and the chorus echo over and over again, "Money fo bag, back fo groun oooo."

There is hardly a song or even a scholarly paper that describes the ordinariness and even banality of the commodification of the body in a neoliberal postcolonial society like Lapiro de Mbanga does with this song, "Pas Argent." There is nothing you get in this world today without money, not even love, as the song implies. Lapiro is very particular about form. About the container. It is not just the content that matters, but also finding the right container for the right content. To critique the commodification and dispensability of lives within such a dictatorial postcolonial context, it wouldn't suffice to sing just in English or French. Neither of these languages can really contain our queries and worries, our pains and fears, nor even our joys or tribulations. So Lapiro uses Pidgin as the container to carry that content and uses pidginization as the technology of sensibilization and resistance.

It is also the dexterity with which he uses Pidgin that matters. Depending on where he wants to lay emphasis and for what precise purpose, he employs the tools of humor (which seems to be inherent in the use of Pidgin), tension, narration, geography (Libreville, Brazaville, Kinshasa, etc.), and even the tone of religion (*Les évangiles selon Saint*

Lapiro de Mbanga. Chapitre dix, verse dix). So, while Lapiro is using Pidgin to describe the marketplace and its practices, it is through that same Pidgin that he intends to dismantle those practices. In the nine minutes and twenty-six seconds of the song, he builds a dramaturgy. It could be a drama reduced, compressed to a poem. Pidgin as poetry and pidginization as storytelling through poetry. Pidgin as a language of ridicule. Ridiculing as resistance. Pidgin as a space of epistemes and pidginization as the practice of finding knowledges, philosophies in spaces other than the colonially prescribed mono-epistemic and universalizing spaces of spaced-out knowledge. Pidgin as the embodiment of the pluriverse and pidginization as the manifestation of pluriversalities. Pidginization as a method of curating proposes a practice of curating as a space of encounters, resistances, and pluralities.

The Offering

There are probably more people around the world who speak some form of Pidgin and live some form of pidginization culture than those who speak the supposedly dominant colonialist languages of English, French, Spanish, German. Come to think of it, these supposedly dominant languages and ways of being in the world are actually very peripheral. So, if we are tasked to think of curatorial practices for a space of world cultures and in a time when the collapsing distances between geographies and their epistemes are provoking violent reactions from the white-supremacist, right-wing, colonial establishments, it goes without saying that we must engage in and with curatorial concepts and ways of being in the world related to Pidgins and pidginization. Curating through Pidgin and pidginization means reaching out to artists, scholars, musicians, philosophers, storytellers, poets, scientists, and people from other walks of life to deliberate not only cognitively but also phenomenologically and spatially on concepts, spaces, and cultures of pidginization.

If we are asking our audiences from plural cultures and languages to take our curatorial practices seriously, then we must offer them something that connects to their diverging histories, languages, cultures, philosophies, and more. To curate is to employ and deploy Pidgins toward a *corpoliteracy* that contextualizes bodies as the platform and medium of a maroonage through learning.[14] This pidginized

curating is a curating that combines works, ideas, practices, and languages in resistance to canonical conventions, cultural stasis, ossified practices, dead rhythms, and singular forms where and when there must be constellations of the pluriversal. A pidginized curating is to speak, think, dance to, and live pidginizations through Fanagalo, Hawaiian pidgin, Wolof pidgin, Kru pidgin, Thai pidgin, Camfranglais, Tok Pisin, Mboko Tok, Nigerian Pidgin, Swahili, and the many more awaiting your invention, the many more to come.

14 Corpoliteracy is a concept I have been developing over the past years. Corpoliteracy can be understood as an effort to contextualize the body as a platform and medium of learning, a structure or organ that acquires, stores, and disseminates knowledge. This concept would imply that the body, in sync with, but also independent of, the brain, has the potential of memorizing and passing on/down acquired knowledge through performativity—through the prism of movement, dance, rhythm. See Bonaventure Soh Bejeng Ndikung, "Corpoliteracy: Envisaging the Body as Slate, Sponge, and Witness" in *I Think My Body Feels, I Feel My Body Thinks: On Corpoliteracy*, ed. Nick Aikens and Yolande Zola Zoli van der Heide (Eindhoven: Van Abbemuseum, 2022), 13–18.

Messing with the
Language of Curating

Curating, as a discipline, has in recent years earned a rather unfortunate and increasingly uncomplimentary reputation.[15] The reasons for this seem to be multifold, and have possibly been addressed by every generation of curators; ours, too, must face these challenges. Essentially, among many other complaints, curating and curators are accused of being elitist, self-referential, practicing within an echo chamber. Whether these accusations are right or wrong is beside the point, and I do not feel the need to defend the discipline of curating, but I am interested in deliberating on causes and effects as well as finding ways of acting outside of the echo chamber, finding ways of making the canon of curating more porous, or to put it in less subtle terms, bursting the bubble that is curating.

In recent years, we have seen museums and other art institutions struggle with questions about their audiences. "Diversity" has become the key word in an age of curatorial sloganism. To be able to get funding from state and parastatal funding

15 Though there are no statistical survey results to make this
 claim, I am writing based on general feedback and a particular
 vantage point as a practicing curator who works on an average
 of eight to ten large-scale group and individual exhibitions
 a year, spanning multiple geographies, and as a professor in
 a master of arts program in spatial strategies, with students
 from various disciplines, including curating.

structures, one has to claim diversity (especially of the audience, less so of the teams) in terms of racial affiliations, gender, sexuality, age, ableism, and more. One of the many reasons why this is happening at this time is the realization that curators in many art institutions have produced and are still producing exhibitions for a "normative" audience of mostly white, middle-class members of society.[16] Issues of interest for migrants, racialized members of society, and otherly abled citizens have been at best, peripheral, and at worst, non-existent. And in the rare cases of peripherality, the curatorial method follows the trajectory of "about us, but without us." What has been portrayed here using broad strokes has led to the boom of what I would like to call the *outreach complex*.

The outreach complex is the effort to compensate the lack of diversity in an institution's audienceship by employing, for example, someone who identifies as queer, or is a person of color, to be the liaison between the institution in question and some supposed community that needs to be reached. The preprogrammed failure of the outreach complex is less about the fact that this method of reaching out to people might actually contribute to their

16 It's important to point out here that I am looking mostly at museums in the context of Europe. I have written about this extensively in other essays, such as "The Globalized Museum? Decanonization as Method: A Reflection in Three Acts," in my book *In a While or Two We Will Find the Tone: Essays and Proposals, Curatorial Concepts, and Critiques* (Berlin: Archive Books, 2020), 183–92.

othering, but more about the fact that these so-called communities being reached out to are still not given any reason to come to these institutions—especially on a regular basis. By this I mean that if the subject matter of curated exhibitions is geared toward the normative *Mehrheitsgesellschaft*, or majority society, and the people from these marginalized communities do not see themselves in the stories told, in the questions posed, in the concerns evoked in these exhibitions, then no amount of "outreach" will make them feel comfortable in such curated exhibitions.

Let us place the subject matter of exhibitions, the scenographic display of exhibitions, the strategies of mediation, the pedagogic formats put in place to disseminate the knowledge generated and cultivated within an exhibition under the banner of "language of curating" or "grammar of curating." If that's the case, then the curatorial practice developed over the course of thirteen years at SAVVY Contemporary in Berlin, of which I am the founder and was the artistic director (until December 2022), has been one of "messing with the language or grammar of curating." But more about the SAVVY Contemporary context soon. The strategy of "messing with the language or grammar of curating" is a fundamental part of "pidginization as curatorial method."

A case study for "messing with the language or grammar of curating" would be documenta fifteen in Kassel (2022). Before getting into the details of the curatorial practice of this documenta and how it fits with the concept of pidginization at large, it is important to mention that some works presented

at documenta fifteen carried racist and antisemitic symbolism that I fully condemn. It is important to state this disclaimer as the curatorial practice described in this essay does not condone any form of hate or abuse and should instead promote the principle of *vivre ensemble* (living together). Ruangrupa, an Indonesian collective that served as the curators of documenta fifteen, have insisted on the fact that their assembling call for the quintennial exhibition, a *lumbung*,[17] is not a concept, but a practice. A practice that "enables an alternative economy of collectivity, shared resource building, and equitable distribution. Lumbung is anchored in the local and based on values such as humor, generosity, independence, transparency, sufficiency, and regeneration." Ruangrupa goes on to write that the "practice changes dynamically through interactions between people. Therefore, documenta fifteen is not theme-based. It is not about lumbung, but it evolves together with lumbung. Documenta fifteen is practicing lumbung. This affects the artistic process, which is shaped collectively. Practicing lumbung means that the exhibition is not static."[18]

The lumbung experience in Kassel—though some images and communication strategies were reproachable and must be condemned—has been an experience of care, of giving and receiving space,

17 *Lumbung* is the Indonesian word for a communal rice-barn, where the surplus harvest is stored for the benefit of the community.

18 "Lumbung," documenta fifteen website, accessed November 11, 2022, https://documenta-fifteen.de/en/lumbung/.

of subverting the languages of art, and also of dismantling the course and practices of exhibition making.[19] The generosity of forms chosen (sitting spaces for visitors, spacious displays of works, and performative works, for example) and the artistic languages used are in line with pidginization as a culture of resistance to homogenous and normative structures. The lumbung as a call for collective action seems to be an important twist in an era of hyperindividualism. Being part of a collective is a political gesture, and inviting collectives to make up the backbone of an artistic project of this scale is an important hacking of the curatorial. Questions of curatorial responsibility in collective curatorial practices need to be more seriously discussed in the years ahead: Who decides which artists and what kind of works are presented in an exhibition? What kind of care is offered with regard to the content and containers displayed? What forms of contextualization and mediation of artworks can be offered for different audiences in different cultural and geographical zones? Who shoulders the responsibilities in difficult situations?

In significantly different ways, efforts and methods of hacking the curatorial have been at the core of SAVVY Contemporary's practices for a long

19 Editor's note: For more context about the controversy surrounding documenta fifteen, see, for example, Siddhartha Mitter, "Documenta Was a Whole Vibe. Then a Scandal Killed the Buzz.," *New York Times*, June 24, 2022, accessed February 8, 2023, https://www.nytimes.com/2022/06/24/arts/design/documenta-review.html.

time. By insisting on the art space and on curatorial practice as a practice of hospitality and conviviality, by inviting agents (including artists) of various disciplines to contribute elements (including art) to make up exhibitions, by bringing in the performative elements of care work, like setting up a nail polishing studio, or a kitchen, or an information center for refugees in the exhibition space, as part and parcel of curated exhibitions, we have sought to stretch what the meanings of art, exhibition, and curatorial practices are. It is "pidginization as curatorial method" that has allowed SAVVY to negate the notion of the "institution" and instead to focus on the practice of the "institution in becoming" and on instituting itself as a curatorial practice. By this I mean the act of putting things in place, the act of being in flux, of being dynamic/non-static, of cultivating the variation of form-ideas as method.

Regarding the issue of messing with form and language, it wasn't just the "subject matter" of documenta fifteen that left an impact on many, but also the scenographic display of the exhibition. There was a looseness, an unpretentiousness, an unassumingness that comes with not wanting to be a sheer mimicry of something else, but wanting to define a new, or at least another, trajectory. This trajectory has been one taken by artistic structures like Khiasma/Un Lieu Pour Respires, Paris; RAW Material Company, Dakar; TEOR/éTica, San José; Colomboscope, Colombo; Chimurenga Factory, Cape Town; and SAVVY Contemporary, Berlin. These structures of artistic practices in their

different geographies and cultural scapes have, in my opinion, developed curatorial formats that have pushed the boundaries of conventional curatorial practices and thereby established some sort of curatorial pidginization.

In some of the first exhibitions at SAVVY Contemporary in 2010, we would invite neighbors to cook in the exhibition space amid exhibited artworks. We invited these neighbors to bring vinyls with them, which we listened to while they cooked and while we ate. The initial reaction from the audiences who came to SAVVY Contemporary just to see art hanging on the walls was one of reservation and concern. Questions came up, like "Where is the art?" And exclamations such as "This is not art!" were too often thrown around in those early days. Over the course of time, the culinary aspect of SAVVY's curatorial practice has become part and parcel of the space, and what I will call *indisciplinary* curatorial practice—a pluriversal constellation that embraces all disciplines, that understands disciplines within the concept of pidginization—has influenced other institutions around us, and of course elsewhere, as I mentioned above.

Is it necessity or scarcity that is regarded as the mother of invention? Be that as it may, it was the combination of scarcity and necessity that prompted performative projects on the streets in the Neukölln neighborhood of Berlin, where SAVVY was previously located (it is now situated in Berlin's Wedding neighborhood). Back then in 2010, our space was too small to host a stage for

performing artists and enough of an audience for them. Thus, on a very regular basis, we would appropriate the pedestrian paths of Richardstrasse in front of SAVVY as our stage for performances. This soon became the Saturday evening event for most neighbors, who brought down chairs from their apartments, bought a beer from a kiosk, and watched the performances. At the core of this curatorial practice wasn't just the need to present the body as an object, but to understand the body as a medium of identification, of knowledge cultivation and knowledge transfer in a place like Neukölln, which is populated by people from approximately 160 nations from around the world. In such a curatorial practice of pidginization, the art is the outreach and not the symbolic politics of superficial association.

Curatorial indisciplinarity, which is the backbone of messing with the language or grammar of curating, which is the marrow of pidginization as curatorial method, manifests itself in manifold ways. And so:

What language do we use in formulating and disseminating the curatorial concepts and practices we put in place? In thinking about messing with language in curatorial practices, we at SAVVY Contemporary have literally employed Pidgin as the language in which we often write and communicate. But with every exhibition, we also employ the format titled "SAVVY Speaks in Tongues," whereby the mediation of the exhibition is done in Pidgin, Spanish, Farsi, French,

Nguemba, Portuguese, Tagalog, or even English. This practice of testing the threshold of language comes with radically questioning the hegemony of certain languages, how they are used, by whom, and when.

Who do we reference and on whose shoulders do we stand to look ahead?
The politics of referencing plays a key role within certain circles of public expression. It is this politics of referencing that has guaranteed spaces in the canon for a long line of French or German philosophers, who are like cemented pedestals on which an army of British and American theorists stands. These few thinkers are cited over and over again within certain curatorial circles as a way to legitimize the points these curators make—for better or for worse. At the core of SAVVY Contemporary's curatorial indisciplinarity, messing with the language or grammar of curating, and pidginization as curatorial method is the claim of those spaces of referencing for others. My grandmother is as good a reference for what we want to do as any philosopher, and "Mamy-Achombo" selling "beignet-haricot" to her clients every morning has knowledge about her society that few anthropologists or sociologists can attain.

It is said that the closer one comes towards a light source, the larger one's shadow becomes. And the larger the shadow, the more others can be hidden under the darkness of that large shadow. Western thought, Western philosophy and practices have been placed too close to the light source when it comes to curatorial practices. So, in reimagining

the politics of referencing within the practice of curatorial indisciplinarity, one must gently shift the light source, thereby taking away the shadow that has been falling on the multitudes and keeping them in some artificial obscurity. To give space to the voices of thinkers and practitioners from the non-West, to invite musicians, performers, scientists, sociologists, and people from varying walks of life and a wide range of geographies to stand in the light is at the crux of pidginization as curatorial method.

Who curates and who's the audience?
That knowledge is embodied is something embedded in most Indigenous and non-Western cultures. The purported division between mind and body never made sense to them. It is this fundamental knowledge that has served as a point of departure in conceptualizing and practicing curatorial projects at SAVVY Contemporary and likeminded places. It is a question of who speaks, how, and who listens. The embodied knowledge brought by the "speaker" and how this knowledge is cultivated and disseminated, conditions and is conditioned by the embodied knowledge of the "listener." This curatorial practice we have been cultivating is primarily based on a culture of listening. A listening to each other and to inner voices. A listening to voices and other sounds from the fringes. Of laying emphasis on listening to those who swallow their words, who speak between the lines, who speak under the radar because of historical disenfranchisement or because the threshold has been set so high as to keep them out or keep them unheard.

This curatorial practice we have been cultivating is secondarily based on a culture of speaking such that the other understands. Not a speaking for oneself, not a speaking to oneself, not a speaking for speaking's sake, but a speaking that is generous. A speaking that goes beyond language. It is a curatorial practice based on generosity, on conviviality and hospitality. The epitome of such a curatorial practice of listening could be found in the November 2022 collaboration between Colombian artist Oscar Murillo and SAVVY Contemporary for the exhibition "A Storm Is Blowing from Paradise" at the Scuola Grande della Misericordia, Venice.[20] The exhibition brought together works predominantly from Murillo's *Frequencies* series, produced in collaboration with students aged ten to sixteen from 350 schools worldwide, which was activated by SAVVY Contemporary's curatorial format that we call "Invocations." Twenty musicians from Colombia, and over twenty other poets, musicians, performance artists, and theoreticians from Haiti, Nigeria, Ghana, the United States, Cameroon, and beyond came together to dig, jam, and bond through four historical and aesthetic moments of dispersal, convergence, fragmentation, and reconfiguration. Despite the challenges of language, there was a deeper communication enabled by using the tools of curatorial generosity.

20 "Oscar Murillo: 'A Storm Is Blowing from Paradise,' Scuola Grande della Misericordia, Venice, 17.09–27.11.22," Storm from Paradise website, accessed November 11, 2022, https://www.stormfromparadise.com/en.

Another element crucial to crafting and implementing curatorial generosity is the usage of the spaces in which we curate exhibitions. Murillo's vessel to host the artists and visitors was akin to the seating in the British parliament, with those sitting on the left and right of the aisle seeing each other and the performative acts on view at the same time. In the same spirit, Ruangrupa's documenta fifteen lays emphasis on lounges and other sitting areas, accommodation facilities that permit visitors to rest, be settled, and be grounded, while also allowing for encounters and exchanges between the people experiencing the exhibition. Another effort of artistic and curatorial generosity could be seen in Ibrahim Mahama's *Parliament of Ghosts* for the sonsbeek20→24 exhibition in Arnheim, the Netherlands, which I conceived as its artistic direc-tor. Mahama's installation, with its arrangement of worn plastic train seats from defunct railroad cars that was hosted over the whole period of the exhibition, was the setting for the performance and lecture series "sonsbeek Sunday service." Or before this, in 2017, it could be seen in documenta 14's "The Parliament of Bodies," a program that hosted public discussions for one hundred days in Athens and Kassel, bringing together people identifying in different ways, and from across many geographies and urgencies, to engage in conversations about pressing issues of the time.

To whom does it belong?

In the curatorial process leading up to documenta 14, its artistic director, Adam Szymczyk, often asked his curatorial team, of which I was a member, as well as the funders of the quintennial, "To whom does documenta belong?" Or, "For whom are we making this?" These fundamental questions have accompanied me in my curatorial process ever since, and in the process of instituting as curatorial practice, or storytelling as curatorial practice, or in practicing curatorial indisciplinarity, I have kept these questions as a leitmotif.

Dr. Bonaventure Soh Bejeng Ndikung (born in 1977 in Yaoundé, Cameroon) is the director of Haus der Kulturen der Welt (HKW) in Berlin. Previously, he founded SAVVY Contemporary in Berlin, of which he was its artistic director. He also served as artistic director of Sonsbeek20→24, a quadrennial contemporary art exhibition in Arnhem, the Netherlands, and of the 13th Bamako Encounters 2022, a biennial for African photography in Mali. Ndikung was the curator-at-large for Adam Szymczyk's documenta 14 in Athens, Greece, and Kassel, Germany, in 2017; a guest curator of the Dak'Art biennale in Dakar, Senegal, in 2018; as well as artistic director of the 12th Bamako Encounters in 2019. Together with the Miracle Workers Collective, he curated the Finland Pavilion at the Venice Biennale in 2019. He was a recipient of the first OCAD University International Curators Residency fellowship in Toronto in 2020 and is currently a professor in the master of arts program in spatial strategies at the Weissensee Academy of Art in Berlin.

Thoughts on Curating, volume 3

Bonaventure Soh Bejeng Ndikung
Pidginization as Curatorial Method:
Messing with Languages and Praxes of Curating

Published by Sternberg Press

Editor: Steven Henry Madoff
Copyediting: Anita Iannacchione
Proofreading: Melissa Larner
Design: Bardhi Haliti
Typeface: Magister (Source Type)
Printing: Printon, Tallinn

ISBN 978-1-915609-08-3

Distributed by The MIT Press, Art Data,
Les presses du réel, and Idea Books

MA Curatorial Practice
School of Visual Arts
132 West 21st Street
New York, NY 10011
www.macp.sva.edu

Sternberg Press
71–75 Shelton Street
London WC2H 9JQ
United Kingdom
www.sternberg-press.com

Thoughts on Curating
Series edited by Steven Henry Madoff